Design & Concepts L.L.C
January's Issue

House of:
Lisabeth Design

Today's Issue:

- *Doggy's world*
- *Fashion No's*
- *Design or Not*
- *Featured Business*

House of Lisabeth Design Magazine 2014

- HEALTH TRENDS
- WHATS GOING ON
- DOGGY'S WORLD
- THE BUZZ
- FASHION NO OR NOT- FASHION THIS OR FASHION THAT
- NIGHTLIFE
LISABETH DESIGN
- DESIGN THIS-
- TRENDY OF 2013-UP TO THE MINUTE 2014
- LIVE EVENTS
WHATS WHO, WHOS WHAT
- FEATURED BUSINESS: BUSINESS OF- YESTERDAY, -TODAY, AND TOMORROW
- (ARIZONA EVENT(S)
- POLICTICS TRANSFORMED
- FIND US!
CALENDER

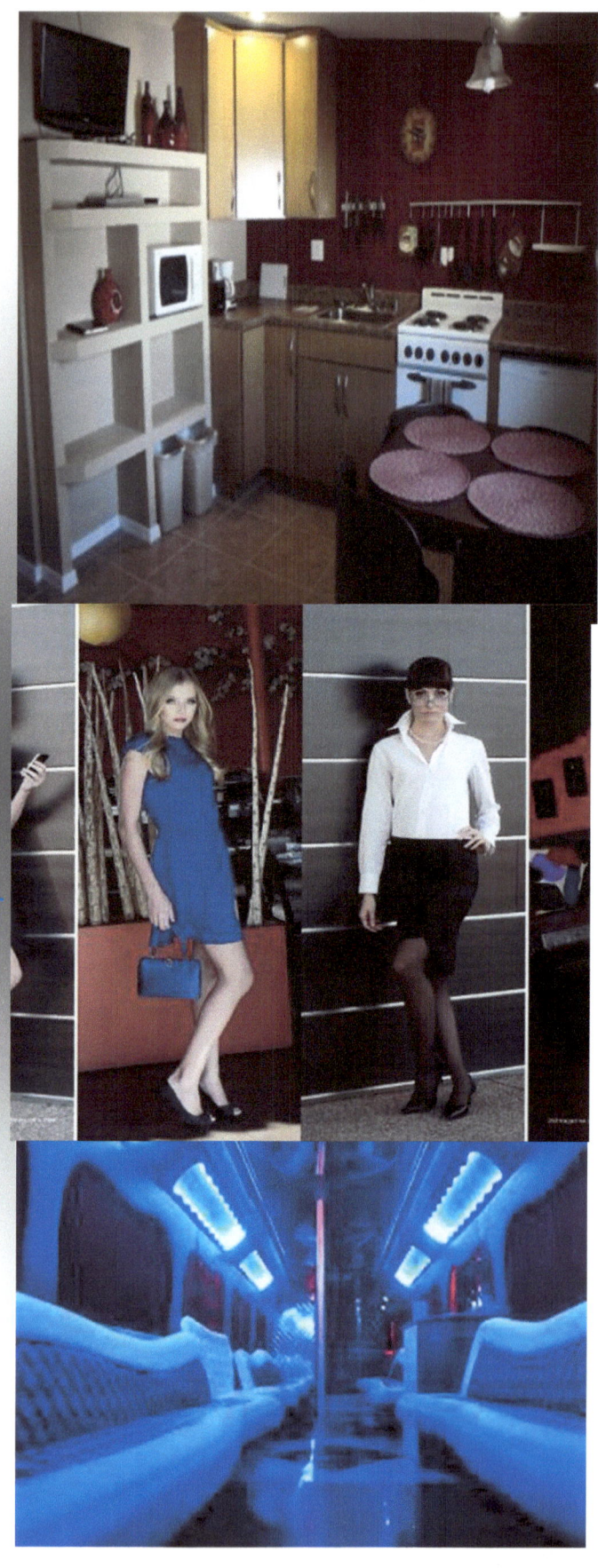

Health

Get rid of those Nasty New Years Headaches

Ever get those feelings when you feel as if your head and eyes and everything on your face is going to pop like a exploding volcanoes? Well that is one of two things a really bad hang over or a headache. And as generic as it sounds it can become a real problem and affect you through out the day. A headache, medically known as cephalalgia, is a continuous pain in the head. The pain can be anywhere in the head or neck. As the brain has no pain receptors, headaches are not felt in the brain. The pain is caused by disturbances of the pain-sensitive structures around the brain.

Some Causes;

- Stress
- Depression
- Anxiety
- Bad Posture

Editors Features

- Staying in one position for too long
- Working in a awkward position for too long
- Clenching ones jaw
- Caffeine (drinking large amounts of caffeine)

Things you can do ;

- *Keep a good life style*
- *Diet*
- *Exercise*
- *Keep a journal of occurrences to monitor*
- *Seek a medical professional*
- *Take over the counter presciptions (as directed)*
- *Drink lots of water*

Local Business Ad for sale
See back of magazine for
More information!

The World of Entertainment

TOP PICKS OF THIS MONTH.....

Dead Ever After (Sookie Stackhouse/Southern Vampire series#13)

When a shocking murder rocks Bon Temps, Sookie will learn that what passes for the truth is only a convenient lie. What passes for justice is more spilled blood. And what passes for love is never enough...

The Spider (Elemental Assassin Series #10)
By: Jennifer Estep

Ten years ago. A blistering hot August night. I remember like it was yesterday. The night I, Gin Blanco, truly became the Spider.

Dangerous Women
By: George R.R. Martin

Writes Gardner Dozois in his Introduction, "Here you'll find no hapless victims who stand by whimpering in dread while the male hero fights the monster or clashes swords with the villain, and if you want to tie these women to the railroad tracks, you'll find you have a real fight on your hands.

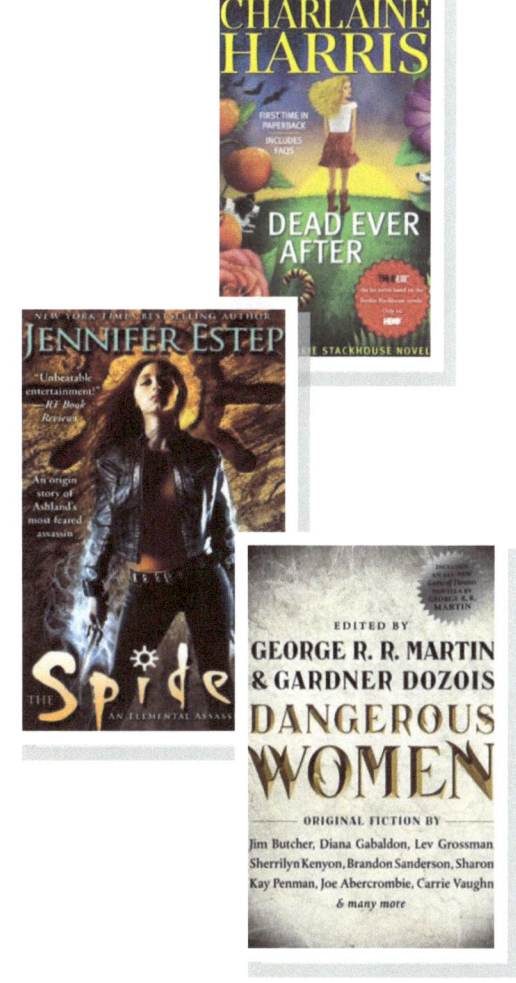

Doggy's World
Music Events:

U.S. Airways Center Presents

Phoenix Suns VS Memphis Grizzlies
Jan 2

Disney on Ice Presents Rock-in Ever After
Jan 8

201 E Jefferson St. Phoenix, AZ 85004 602-379-7878

Marquee Theatre Presents

Janell Monae
Jan 11

Falling in Reverse
Jan 17

1 E Main St. Mesa, AZ 85201 480-644-6501

Fashion No or not….
Brought to you by: Lisabeths Design

THE PINK LOOK

This year we tried to find a fresh new look that represented the new year. Well we looked and leaned toward PINK!

Pink is a florescent color with rich looks and feel. It makes you feel fresh and new and close to younger. The best shades are pink and maroon. The best time of day is early morning to mid day. I like a little pink in the mid day with a nice sun look some shimmer and gloss. To me pink always represented the younger side of me, like a fresh face hardly no make up look. And we all like that.

Here is some fun facts to go along with your pink look…..

Pink Lipstick

Television Program

Pink Lipstick is a 2010 South Korean television drama starring Park Eun-hye, Lee Joo-hyun, Park Kwang-hyun and Seo Yoo-jung. It aired on MBC from January 11 to August 6, 2010 on Mondays to Fridays at 7:50 a.m. for 149 episodes. Wikipedia

First episode: January 11, 2010

Network: Munhwa Broadcasting Corporation

Language: Korean

Genres: Comedy, Korean drama, Drama

Here is some places to shop for pink lips….
Www.yandy.com
Www.makeupgeek.com
Www.maccosmetics.com
Www.pinklipsticklingeri.com
Www.polyvor.com

DESIGN SEO STYLE CREATE SEO LIFE

Driven to Surpass
We are all driven to surprises our needs for something greater. A key thing to remember is that in a business like this the only thing you can say is the customer is always right.
Our business is design and the world of design is like any thing else. The key thing to remember is structure and knowing that design takes form of shape and life.....
Our packages remain the same because we designed them to be an easy by. An easy way to remember is that simply or drive is to motivate you to by the key components of your design. The ink, the color the shape.
Surpass is another key idea. I wanted to avoid going to the malls for days why because I wanted to surpass the flashing sights and lights that pointed toward buy here bye her. So I instead opt for making a list. Making a list of things that I might need for things that are important. It's called budgeting but in my world I just called it drive to surpass.
That's what we do as far as pricing for your needs and services, it's about getting what you need before over paying. The right way to shop and approach customers.

Featured Business: Business of today tomorrow

Spoke Wheel Tavern and Eatery

This great place a tavern and eatery and place for the every day commuter can come and enjoy some food and drinks. With specials and places to park your bike this is a one of a kind place.

Spoke & Wheel is a family-style tavern and chef-driven eatery serving up contemporary American cuisine with a Southwestern flair.
Our kitchen takes pride in seeing the freshest of ingredients. We grind our meat in-house and bake our bread daily.
Try one of our Kraft-made cocktails prepared with organic syrups. At Spoke & Wheel Tavern, we welcome you and your family, and are committed to giving you great service and delicious food at reasonable prices.

Located at :

8525 N. Central Ave., Phoenix, AZ
T. 602.870.8843

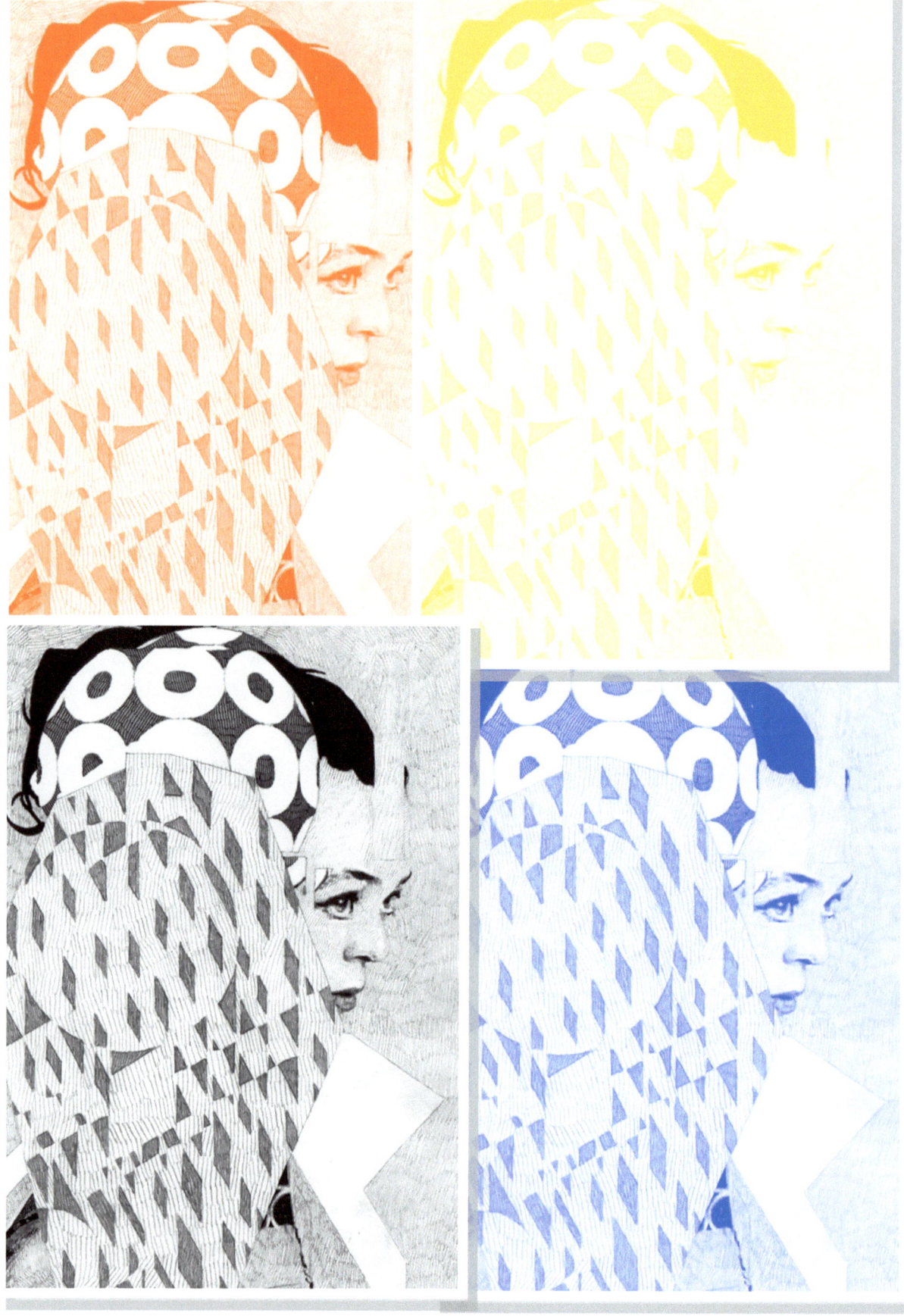

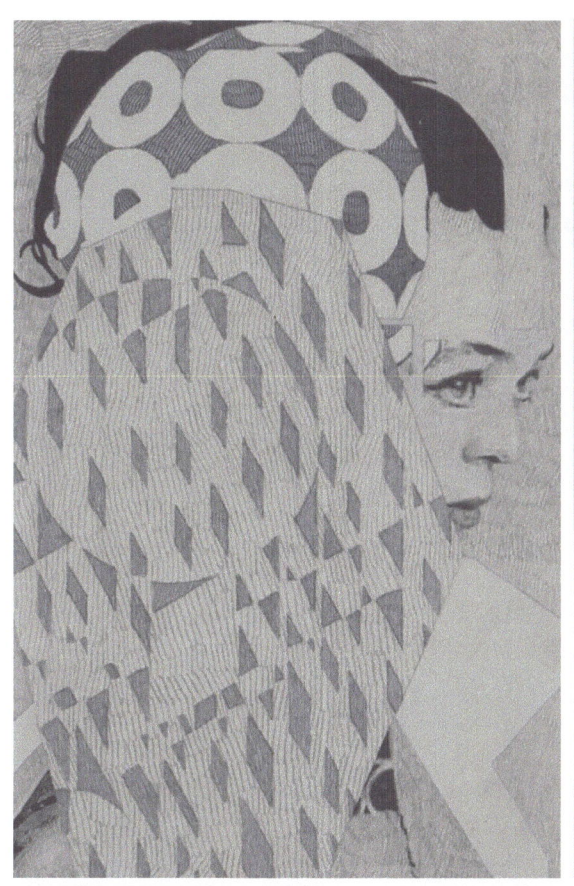

Trendy News What You Want To Know

Khole Kardashian who is filling for divorce from Lamar Odom is said to have filed under irreconcilable differences. They allegedly having been going through issues since Khole has been hush hush about Lamar's infidelities and drug issues. After a DUI arrest and more issues they decided to separate, Khole who reportedly asked to drop " Odom " from her name, is asking for spousal report.

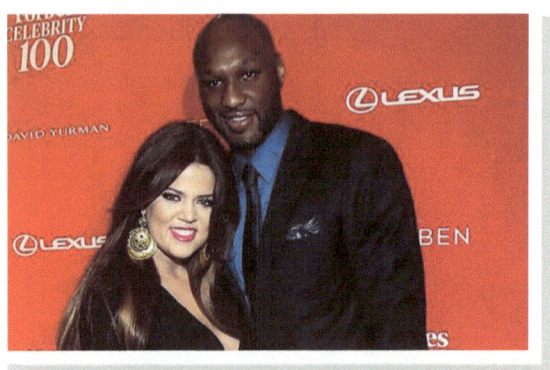

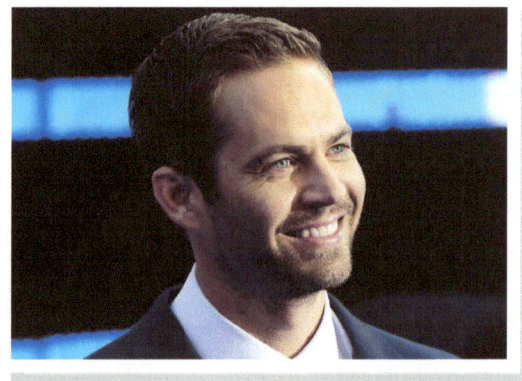

Paul Walker who tragically died in a car crash , in Southern California was missed and mourned by thousand s as they laid tribute to his life. Friends and family mourned as they sent messages and " we miss you " across the web. What started out as a car ride home in a Porches Carrera, ended up in flames with another victim, Rodger Rodas, a pro racer and father of two. Paul Walker who was born September 12, 1973 is an American Actor and a father of two.

New Technology For The Modern Geek

Can you identify with comic strip panels where a particular detective goes around a crime scene with a magnifying glass in hand? That detective will be peering closely at all of the different clues around him, trying to see what kind of dastardly evidence that the murderer or thief left behind in order to make sure that the long arm of the law catches up eventually. More often than not, the eye of the detective will be blown up when seen from the other side of the magnifying glass, which is something your eye could look like with the $199.95 Detailed Task Magnifying Glasses in hand.

There are a few standard pieces of hardware we use for our computers. They come in various shapes and sizes with different features, but we all have a mouse, monitor, and keyboard. While some have more buttons than others, you don't normally find any that are so over the top that they have a price tag in the thousands.

New Technology Vs. The other guys

The human species' use of technology began with the conversion of natural resources into simple tools. The prehistorical discovery of the ability to control fire increased the available sources of food and the invention of the wheel helped humans in travelling in and controlling their environment. Recent technological developments, including the printing press, the telephone, and the Internet, have lessened physical barriers to communication and allowed humans to interact freely on a global scale. However, not all technology has been used for peaceful purposes; the development of weapons of ever-increasing destructive power has progressed throughout history, from clubs to nuclear weapons.

Technology has affected society and its surroundings in a number of ways. In many societies, technology has helped develop more advanced economies (including today's global economy) and has allowed the rise of a leisure class. Many technological processes produce unwanted by-products, known as pollution, and deplete natural resources, to the detriment of Earth's environment. Various implementations of technology influence the values of a society and new technology often raises new ethical questions. Examples include the rise of the notion of efficiency in terms of human productivity, a term originally applied only to machines, and the challenge of traditional norms.

Philosophical debates have arisen over the present and future use of technology in society, with disagreements over whether technology improves the human condition or worsens it. Neo-Luddism, anarcho-primitivism, and similar movements criticise the pervasiveness of technology in the modern world, opining that it harms the environment and alienates people; proponents of ideologies such as transhumanism and techno-progressivism view continued technological progress as beneficial to society and the human condition. Indeed, until recently, it was believed that the development of technology was restricted only to human beings, but recent scientific studies indicate that other primates and certain dolphin communities have developed simple tools and learned to pass their knowledge to other

Enhancement

Human enhancement refers to any attempt to temporarily or permanently overcome the current limitations of the human body through natural or artificial means. The term is sometimes applied to the use of technological means to select or alter human characteristics and capacities, whether or not the alteration results in characteristics and capacities that lie beyond the existing human range. Here, the test is whether the technology

In scientific usage, a phenomenon is any event that is observable, however common it might be, even if it requires the use of instrumentation to observe, record, or compile data concerning it. For example, in physics, a phenomenon may be a feature of matter, energy, or space-time, such as Isaac Newton's observations of the moon's orbit and of gravity, or Galileo Galilee's observations of the motion of a pendulum.[4] Another example of scientific phenomena can be found in the experience of phantom limb sensations. This occurrence, the sensation of feeling in amputated limbs, is reported by over 70% of amputees. Although the limb is no longer present, they report still experiencing sensations. This is an extraordinary event that defies typical logic and has been a source of much curiosity within the medical and physiological fields

In recent decades, a new possibility for LGBT parenting, same-sex procreation (where two women could have a daughter with equal genetic contributions from both women, or where two men could have a son or daughter with equal genetic contributions from both men), has become a possibility, through the creation of either female sperm or male eggs from the cells of adult women and men. With female sperm and male eggs, lesbian and gay couples wishing to become parents would not have to rely on a third party donor of sperm or egg.

Social apps and more
Find us !

The online world

According to America Sources

When you are deciding to go to college you want the best. If you're a child you want to go with the most available. Some choose for degree and some choose for location, friends, family. If you're a parent you want something that your child is going to succeed, and also help with your pockets. Picking the right school can be easy if you research correctly. From the 43 greatest college quotes, we pick from Steve Jobs." I naively chose a college that was almost as expensive as Stanford, and all of my working-class parents' savings were being spent on my college tuition. After six months I couldn't see the value in it. I had no idea what I wanted to do with my life and no idea how college was going to help me figure it out. "Steve Jobs

So with a little inspiration and some mutual motivation for both of you, here is the Americas list of the top 10 Colleges around:
1. **Stanford University**
2. **Pomona University**
3. **Princeton University**
4. **Yale University**
5. **Columbia University**
6. **Swarthmore University**
7. **United States Military Academy**
8. **Harvard University**
9. **Williams College**
10. **Massachutes Institute of Technology**

Survive The Realestate Market

What is soon to come for Phoenix Arizona and the Real-estate market?

Well according to sources; The housing market will recover but at a slower rate. What dose this mean? Experts say the 25 to 30 percent year-over-year price spikes Phoenix saw consistently throughout 2013 will look more like 6 or 8 percent in 2014.

Another thing to watch is the mortgage sector. Experts agree that the 3.5 interest rates are long gone and now a days it will be much higher. The [Federal Reserve](#) said last week it will begin to wean the economy off of its $85 billion monthly bond buying program next year in an attempt to lure private capital back to the mortgage sector, but it's unclear how investors and the financial markets will react. So with those small little bit of updates you can see that the coming year will be a new and leveling time for the phoenix market.

Politics: Special Feature

Pope Frances wishes for a better world on his Christmas address

Pope Francis called on the world to end the "hatred and vengeance" in Syria and to "heal the wounds of the beloved country of Iraq" in his first Christmas Day speech to an estimated crowd of 150,000 at the Vatican on Wednesday.

In an address dominated by calls to end international conflicts, the pope urged "a favorable outcome in peace talks between Israel and Palestine."

American abducted by Al-Qaeda makes plea

ISLAMABAD (AP) — A 72-year-old American development worker who was kidnapped in Pakistan by al-Qaeda more than two years ago appealed to President Obama in a video released Thursday to negotiate his release, saying he feels "totally abandoned and forgotten."

Cairo Bomb blast adds to crisis in Egypt

High quality global journalism requires investment. Please share this article with others using the link below, do not cut & paste the article. See our Ts&Cs and Copyright Policy for more detail. Email ftsales.support@ft.com to buy additional rights. http://www.ft.com/cms/s/0/85f25ef6-6e25-11e3-8dff-00144feabdc0.html#ixzz2obelyds0

A crude explosive device on a Cairo street injured five people on a bus on Thursday morning, deepening the sense of crisis in Egypt after a massive car bomb earlier this week which killed 16 people at a security headquarters in the northern town of Mansoura.

The latest bloodshed came just hours after the military-backed government formally designated as a "terrorist organization" the Muslim Brotherhood group of Mohamed Morsi, Egypt's first elected president, ousted by a popularly backed coup in July.

Politics Transformed

Politics: The who and what of Politics

Courts order new election for Israeli

JERUSALEM — An Israeli court has ordered new municipal elections be held in a deeply divided city, citing irregularities in the initial vote.
Beit Shemesh's 100,000 residents are split almost equally between ultra-Orthodox and other Jewish groups, including the secular, the modern Orthodox, Russian and American immigrants and Jews of Middle Eastern descent.
Official results of the October vote showed voters lining up almost entirely along religious affiliation. Incumbent ultra-Orthodox mayor Moshe Abutbul garnered less than 1,000 votes more.

Sony and Panasonic partnership

Sony and Panasonic are scrapping their OLED display TV panel joint-venture "alliance", blaming technical challenges and production costs. The pair will independently focus on building 4K/Ultra-HD LCD panels.
Both companies have faced heavy losses within their TV divisions, and local reports quote spokesmen for both businesses saying that LCD-based 4K displays show greater promise.

The Hobbits beat out Wolf of Wall Street in movie news

The Hobbit and The Wolf were followed by Anchorman 2: The Legend Continues, which added $8.1 million to its gross — making the film's box office to date $56.7 million, or just a few million more than EW thought it might earn over a five-day period. (Anchorman 2's been out since Dec. 15.) Two more Oscar hopefuls — Ben Stiller's Secret Life of Walter Mitty retread, which opened Wednesday, and David O. Russell's hair-raising American Hustle — rounded out the top five, earning $7.8 million and $7.4 million respectively.

January 2014

Sunday	Monday	Tuesday	Wednesday	Thursday	Friday	Saturday
			1	2	3	4
5	6	7	8	9	10	11
12	13	14	15	16	17	18
19	20	21	22	23	24	25
26	27	28	29	30	31	

This month will be a great month!

January is The begining

Join our mailing list and get a free 1 month Subscription to our magazine!

Owner
Design & Concepts L.L.C
Elizabeth Chavez
602-472-2551

Creativedesignconcepts@rocketmail.com

Place orders by email or contact

House of Lisabeths Design Magazine

We were started in 2013 as an independent magazine. Our focus is fashion, health and business. We pride ourselves in the design and diversity we offer.

Exclusivity

Our focus is fashion, health and business. Our fashion section includes tips and trends from all over! We also have a online blog that gets tons of clicks per day, check us out online at

Our business section is used for local or national business to place a Ad or listing of them selfs. We have total exclusivity In that they connect with not only our magazine but all of our networks simultaneously.

Our hope is to reach across the world along with Water 4 Kids International. We plan to donate proceeds to this foundation. Our hope is to provide safe water for east Africa.

Check us out on line, Facebook, Twitter, Tumblr, Amazon, and our affiliates websites like Design & Concepts.

Get a 1 year subscription for $ 35.00————————— ☐

Get a 2 Year Subscription for $ 45.00————— ☐

Payment Enclosed————————————. ☐

Charge My Card——————————. ☐

Pay Later——————————— ☐

<u>Send To:</u>

Design & Concepts
32 e Ruth Ave # 304
Phoenix, Arizona 85020

We also take check, cash and money orders.

Remember when you send for a subscription you get a free t-shirt that says "Lisabeth Design"

Thanks for supporting our fashion blog and Section!

<u>**Personal Info**</u>

Name:

Address:

City, State, Zip:

<u>Credit Card Info:</u>
Visa ☐
Master- ☐ Card
AMEX ☐

Card Number:

Expiration Date:

3 number code:

" Fill out above info and return to address given"

Also with your subscription get a free Lisabeth Design T-Shirt

Available for Men and Women

Check out Design & Concepts Blog

DONT BUY MEAT
The worthy of the worth and the Elite of the Elite make a common general statement. " DONT BUY MEAT!" You may ask what dose this mean, no meat no nothing don't buy it if its not out there for a good reason or a beneficial reason don't buy it. I once took a seminar on how you can here 100 things at a time and not understand everything that you are listening to. For instance a commercial can advertise the same tactics, like hey we have this new and improve staple, but yet what is going to make you buy this new and improve staple in the first place. Putting away your needs and obvious i just so happened to lose my normal staple. You start to realize that you don't need the automatic closer, the quick throw back metal thing that snaps back faster then any other staple after you squeeze. You just need a super awesome staple. A staple the thing of necessity. So by saying this i again , build networks and offer professional opportunities. limitations of the human body through natural or artificial means. The term is sometimes applied to the use of technological means to select or alter human characteristics and capacities, whether or not the alteration results in characteristics and capacities that lie beyond the existing human

Join the Cause!

Check out the "Design for Sick Kids Campaign"

Our Mission
In the beginning we wanted a way to show our passion for design. But this project is turning to be more then that. With so many sick kids and so much that we can give we thought about giving the gift of design.

What We Need & What You Get
Here is what we need
1000 cards , either designed by you or who ever
A contribution as well to our campaign

The Impact
With every card made we will donate a dollar and that card to a local hospital of our choice. So think about all the kids you can help by creating there Christmas card or birthday card and also the contributions that come with it.
Remember every card made we donate $ 1.00 to the cause
Also share your design with the people and get your picture taken with the kids

Other Ways You Can Help Check out our websites
www.designandconcepts.net for more updates on more causes!

http://www.indiegogo.com/projects/design-a-card-for-your-kids/

Also with your subscription get a free Lisabeth Design T-Shirt

Available for Men and Women

Design & Concepts Services

[Www.Designandconcepts.net](http://www.Designandconcepts.net)

Design & Concepts is an online service provider for design and advertising. We specialize in brochures logos and business cards as well as t shirts and sickies. We also do local advertising with in the community. Our prices vary with design but...

Our packages start at $55.00 per package!
Package includes : 200 prints
Gloss or matt finish is $10.00 per set/ per 200

Our Packages also include our Marketing Services, and Discounts on our Advertising Specials in our magazine, House of Lisabeth Design Magazine!

Also with your subscription get a free Lisabeth Design T-Shirt

Available for Men and Women

Design & Concepts Services:

Create various ads and place it on all social networks, web pages and create you tube videos to sell, demonstrate and promote your product

Also place your ad on any media source that is available We can take your campaign and place it on any other media resources you have available not just create a web presence awareness but really hit the market.

.We use digital media like

Email marketing, social network campaigns, print distribution, custom Web Design and SEO

Funny Definition of the month

Economic costs[edit]
The economic costs of managing waste are high, and are often paid for by municipal governments;[10] money can often be saved with more efficiently designed collection routes, modifying vehicles, and with public education. Environmental policies such as pay as you throw can reduce the cost of management and reduce waste quantities. Waste recovery (that is, recycling, reuse) can curb economic costs because it avoids extracting raw materials and often cuts transportation costs. "Economic assessment of municipal waste management systems – case studies using a combination of life cycle assessment (LCA) and life cycle costing (LCC)". Journal of Cleaner Production 13 (2005): 253-263.</ref> The location of waste treatment and disposal facilities often has an impact on property values due to noise, dust, pollution, unsightliness, and negative stigma. The informal waste sector consists mostly of waste pickers who scavenge for metals, glass, plastic, textiles, and other materials and then trade them for a profit. This sector can significantly alter or reduce waste in a particular system, but other negative economic effects come with the disease, poverty, exploitation, and abuse of its workers

"Wastes are materials that are not prime products (that is products produced for the market) for which the initial user has no further use in terms of his/her own purposes of production, transformation or consumption, and of which he/she wants to dispose. Wastes may be generated during the extraction of raw materials, the processing of raw materials into intermediate and final products, the consumption of final products, and other human activities. Residuals recycled or reused at the place of generation are excluded

www.ingramcontent.com/pod-product-compliance
Lightning Source LLC
Chambersburg PA
CBHW050416180526
45159CB00005B/2296